Modern Calligraphy

A Step-by-Step Guide to Mastering Hand-Lettering

Modern Calligraphy

LUCY EDMONDS

DOVER PUBLICATIONS, INC.
Mineola, New York

Bibliographical Note

This Dover edition, first published in 2018, is an unabridged republication of the work originally published as *Modern Calligraphy: A Step-by-Step Guide to Mastering the Art of Creativity* by The Orion Publishing Group Ltd, London, in 2017.

Library of Congress Cataloging-in-Publication Data

Names: Edmonds, Lucy, author.
Title: Modern calligraphy / Lucy Edmonds.
Description: Dover edition. | Mineola, New York : Dover Publications, Inc.,
 [2018] | "This Dover edition, first published in 2018, is an unabridged
 republication of the work originally published as Modern Calligraphy: A
 Step-by-Step Guide to Mastering the Art of Creativity by The Orion
 Publishing Group Ltd, London, in 2017." | Includes bibliographical
 references.
Identifiers: LCCN 2018027169| ISBN 9780486827582 | ISBN 0486827585
Subjects: LCSH: Calligraphy—Technique.
Classification: LCC NK3603 .E36 2018 | DDC 745.6/1—dc23
LC record available at https://lccn.loc.gov/2018027169

Manufactured in the United States by LSC Communications
82758501 2018
www.doverpublications.com

CONTENTS

INTRODUCTION

Congratulations if this is your first step on your modern calligraphy journey—I'm delighted that you have decided to join this incredible community of lettering lovers!

Modern calligraphy has taken the world by storm in the last decade and I'm thrilled to have helped kickstart the UK's obsession with it. I founded and run a stationery boutique, Quill London, and we hosted London's first modern calligraphy workshops in 2014. Since then our workshops have been featured in all kinds of national press, and we've seen several thousand eager students come from all over the world to be part of this super-hot trend. Rather excitingly, many have gone on, through our improvers class program, to turn their new skills into a business or to enhance their existing careers. I've met all kinds of inspiring people who have absorbed modern calligraphy into their jobs—graphic designers, tattoo artists, florists, cake makers, embroiderers and stationery designers. Who knows where this could take you!

But equally, I meet hundreds of people who are seeking an opportunity simply to learn a new life skill, crucially something that takes them away from a screen for a few hours. It's surprising that in this age of digital communication, modern calligraphy could have provoked quite this level of obsession. But perhaps it's because we find ourselves addicted to our phones and laptops nowadays—calligraphy offers a wonderful antidote.

Modern calligraphy is a style of pointed pen calligraphy that's based loosely on the Copperplate style, which originated in England as far back as the

seventeenth century but was prolifically used by eighteenth-century penmen, and then traveled across the world via the clerks of the British Empire. When framed within calligraphy's rich 2,000-plus-year-old history, it's a brand-new phenomenon, having only emerged in the last ten years or so. It's sometimes condemned as merely "fancy writing," and admittedly modern calligraphy is less demanding in its approach than the rigorous traditional scripts of the Middle Ages and Renaissance, so it's widely practiced at a comparatively more amateur level. But this is surely why it's become so wildly popular. It's accessible, anyone can do it, and you can create your very own lettering style from it. Just like Copperplate, which has a set of rules that make it recognizable, modern calligraphy has its own set of characteristics that make it so. This book will show you why modern calligraphy is more than just "fancy handwriting." In fact, it won't necessarily even improve your handwriting.

Every modern calligrapher has their own signature lettering style—sometimes several. As you immerse yourself in this new world, you'll soon be able to recognize the work of your favorite modern calligraphers. Some styles reveal hints of a formal Copperplate education; others are quite the opposite: loose, wild, organic. My lettering style is on the latter half of the spectrum. I am not trained in Copperplate but I highly recommend giving yourself a basic understanding of Copperplate letterforms, as it's beneficial to grasp the fundamental concepts that underpin modern calligraphy if you want to produce the best work. Naturally, in this book you'll be learning my style but I will show you ways to develop your own.

I came to calligraphy quite by accident. A few years ago I began to notice this stylish writing appear on my Pinterest and Instagram feeds, and discovered that it had a name: modern calligraphy. After becoming completely captivated, I

realized that it was almost all coming from the USA and consequently, that there was nowhere here in the UK where you could learn it. I thought it could be fun to put on a workshop event in London for our stationery-loving customers, so I found a fabulous British calligrapher and implored her to teach it to us. That class was meant to be a one-off but Quill has never looked back! Since picking up a pen for the first time in that class I was hooked. But like any skill—learning to drive, speaking a new language or playing a musical instrument—it takes time and practice to master. I have to admit I didn't take to it very easily, and I've progressed only through sheer determination. I am a living example of that age-old mantra "Practice makes perfect!" (Well, there's always room for improvement...)

Modern calligraphy has been an unexpected but exciting twist in my career. I've been lucky enough to work with some incredible brands and people, who have commissioned my lettering style for all kinds of projects, from fashion week invitations and events to personalizing luxury goods, and from bespoke stationery to tattoos. I'm humbled that Quill, along with all the inspirational calligraphers that we have had the pleasure of working with, has been at the forefront of this revival in the UK.

This book is designed for complete beginners to modern calligraphy and presents a step-by-step guide to help get you started. It's tempting to dive straight in to words, but try not to jump ahead too quickly. It's important to get the basics right. If you can learn to have patience, it's the best way to progress, and I promise you will see improvement quickly.

Towards the end of the book I have included some creative ideas for you to put your new skills into use. Your modern calligraphy endeavors don't need to

be ambitious at first—why not try addressing your next letter or birthday card using your new talent?

Practicing modern calligraphy is a perfect way to unlock your creativity. Absolutely anyone can learn—it's irrelevant if you have terrible handwriting and it doesn't matter if you think you aren't creative. In the last half-century, scientists have increasingly studied creativity, and we now know that creativity is something we all have. It's a myth that some people just aren't creative. Being creative is a habit that you can get into. Modern calligraphy is a fantastic exercise for your creative muscle: it requires regular practice to unlock the creative pathways in your brain, and the practice in itself demands your full attention, which in turn rewards you with an almost therapeutic sense of relaxation and mindfulness as you write.

As you start your calligraphy journey I really recommend you to surround yourself with inspiration. Make use of all those digital resources at your finger-tips: explore calligraphy videos on Instagram and YouTube, learn from blogs such as those I've suggested at the back of this book, and engage yourself with the worldwide modern calligraphy community online.

Modern calligraphy is a hobby that you can dip in and out of as and when life and time allow. Just have a go and with a little patience, perseverance and practice you will be creating beautiful lettering in no time at all. Beware: it can become quite addictive! I hope you enjoy it as much as I do.

Lucy x

1

The Materials

Let's begin with the essential materials you're going to need. Below are my favorite tools for beginners, which I give to our workshop students. There's a whole world of different tools out there, which I encourage you to explore, but some are more difficult to use than others, so start with the easiest materials!

BEGINNERS' KIT LIST

- Nikko G nib
- Higgins Eternal ink
- Speedball straight penholder
- Rhodia dotPad

As your confidence and experience grow, you'll want to branch out and experiment with different tools. Here are some additional materials you might want to add to your modern calligraphy armory:

- Oblique penholder
- Sumi ink
- Dr Ph Martin's Bleedproof White ink
- Finetec metallic inks
- Tombow brush pens
- A range of nibs, such as Brause Steno, Gillott 404, Leonardt Principal
- Layout paper
- Bristol board
- Watercolor paper
- A pipette
- Gouache paints in primary colors
- Gum arabic in liquid form
- Canford black paper
- Blackwing pencils
- Faber-Castell dust-free white eraser

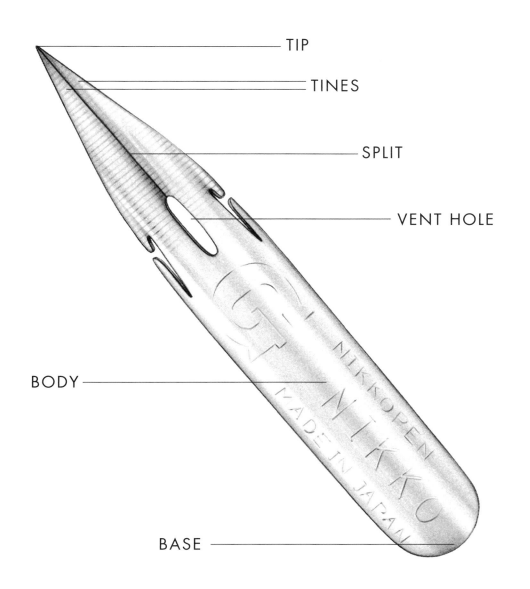

TIP

TINES

SPLIT

VENT HOLE

BODY

BASE

THE NIB

In modern calligraphy we use dip pens rather than fountain pens. The advantage with dip pens is that they can be used with a much wider variety of inks, many of which would destroy a fountain pen by clogging it up. Pointed dip pen nibs are designed to be flexible, responding to pressure to create a variety of line widths on the page—they can make a finer line than any fountain pen.

Modern calligraphy requires nibs that come to a sharp point, rather than nibs that have a broad-edged tip. The good news is that it means modern calligraphy is just as easy for lefties as righties. Nikko G nibs are excellent. They are sturdy, flexible and reliable. Made in their native Japan (but widely stocked all over the world), they are commonly used for the Japanese "manga" comic illustrations.

PREPARING YOUR NIB

New nibs have an oily coating on them, residual from the manufacturing process, which prevents them from rusting or sticking together. You'll need to remove this before using your brand new nib for the first time. There are several ways to do this, and you'll find your favorite method, but passing the writing end of the nib quickly through a flame (from a match or lighter) or cleaning it with toothpaste both work—you can even try leaving it sticking into the flesh of a potato for ten minutes or so!

Once you've gained confidence with the Nikko G nib, there is a plethora of pointed nibs that you can experiment with (the name is minutely etched

into the nib's shank; you have to look closely!). Choose a nib according to what you're looking to achieve on the page. Different nibs suit different inks, penholders and paper types. As with anything new, it's trial and error, but here is a quick crib sheet for some other pointed nibs that I'd recommend experimenting with. Each nib has its own personality and requires a unique approach, from the level of pressure required to how much ink it can take.

NIB	PERSONALITY
Brause "Rose" nib	A nib for a more advanced calligrapher as it's not easy to use but well-loved for its flexible tines. Suits viscous inks best.
Brause "Steno" ("blue pumpkin") nib	So-called for its colour and bulbous shape. Super-flexible but not the finest upstroke. Versatile with all kinds of ink consistencies. Best matched with a straight penholder. Leonardt's Steno 40 nib is similar.
Brause "EF66" nib	Another calligraphers' favorite due to its flexibility and super-fine hairline strokes. Suits thinner inks best.
Leonardt III nib	Rigid flex, suits a contemporary free-and-wild style of lettering. Tough and long-lasting.
Leonardt "EF Principal" nib	Also tricky to use but able to make fine hairlines. Use with thin inks. Very delicate and likely to wear out quickly.
Gillott 404 nib	Delicate but wonderful on smooth papers and easy-ish to use if you're light-handed.

THE PENHOLDER

To keep things simple, I recommend starting with a straight penholder and moving on to an oblique penholder (the one that has a funny-looking attachment on the side of it) after you have got the hang of the letterforms. If you've come to this book already using an oblique penholder, and it's working for you, do continue with it. The oblique holder generally helps you to write at more of an angle, but the slant of your writing is not something you need to worry too much about as you start out. There are other important things to get right first!

The Speedball straight penholder is not particularly glamorous-looking in black plastic but it's inexpensive, fits the Nikko G nib perfectly, and is ergonomically designed to help you grip it in the correct place.

Most other basic straight penholders have a metal claw in the end. The advantage of these is that they will universally fit pretty much all sizes and shapes of nib.

Tachikawa is a Japanese brand that makes a rather nifty straight penholder that comes with a clear lid, to protect your nib. It's not as widely available but a very good idea, I think.

The weight, style of grip and comfort of your penholder comes down to personal preference that will develop over time. I like the cushioning of my cork-tipped penholder.

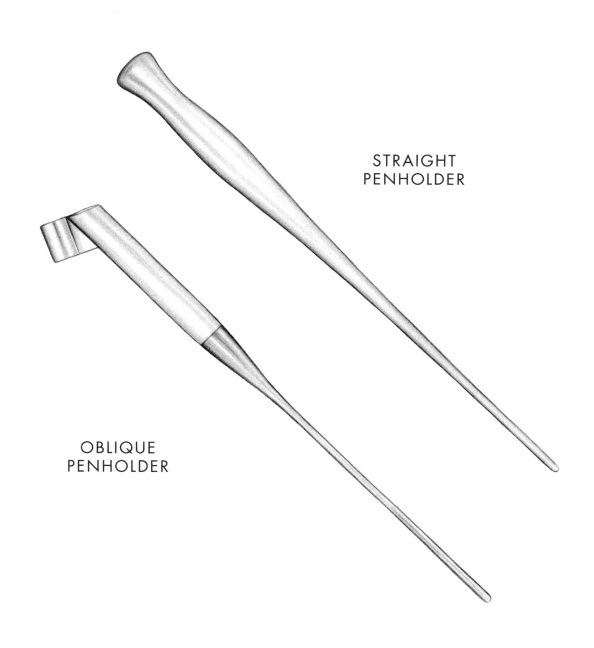

STRAIGHT
PENHOLDER

OBLIQUE
PENHOLDER

THE OBLIQUE PENHOLDER

When you're more confident with your lettering, you might like to branch out and try some new tools. The oblique holder is designed to enable you to write consistently at a slant. A good-quality oblique penholder with an adjustable metal flange would be preferable, but they can be an investment buy. You could start with an inexpensive Speedball oblique holder instead. Once you get the hang of the oblique holder you may prefer it to the straight penholder. My current favorite is my Tom's Studio oblique penholder (illustrated on page 15).

When using an oblique penholder, the long part of the pen should remain in a similar position to your straight holder, because you are allowing the angle of the flange to help you achieve your desired slant. When in this position, the angle of your downstroke should be in line with your nib. It can take a little while to get used to, but do persevere.

INK

Finding an ink you love is a very personal choice and everyone has their own favorite for everyday practice. When weighing up the merits of a particular ink, you might like to consider the following:

Viscosity: Some inks can be thicker than others. To thin down ink, add a drop of water and keep testing it. To thicken, leave the pot open for a few hours or overnight (depending on the volume of ink) and the water content will reduce.

Opacity: Test an ink to see how it dries—does it fade into the paper as it dries? Absorbent papers may encourage the ink to sink in and therefore lose the strength of color, but that can also be a lovely look!

Finish: Do you want a matte or shiny finish when it's dry? India ink tends to dry shiny, and Sumi ink can have a silk-like finish to it. The shiny finish is often produced by shellac in the ink. Shellac is a resin extracted from a particular beetle, so vegans should avoid this.

Acid content: Some inks have a higher acid content, which means that they will not be suitable for archival work and can also corrode your nibs with long-term use.

Lightfastness: Will the ink fade in sunlight? Check the manufacturer's advice.

Waterproofness: Do you need the ink to be waterproof when dry? This is important if you plan to apply a secondary layer, for example a watercolor wash, over your writing. Always make sure to test this first if so.

MY FAVORITE INKS

Higgins Eternal ink is great for beginners and I highly recommend it. It's fairly thin, which makes it easy to use, but therefore has a tendency to "bleed" on thin paper like cheap copy paper. But it's acid-free and shellac-free, and works perfectly with the Nikko G nib.

TIP // Inks stain so be sure to protect your clothing and nearby furnishings when practicing, in case of a spillage. Don't allow ink near any bare, unvarnished wood.

TIP // When using an ink for the first time, test to see how it dries on your paper to make sure it gives the look you want.

India ink, also known as China ink, is thicker, and historically made with a fine soot pigment called lampblack. It dries with a sheen due to its shellac content, and is waterproof once dry.

Iron gall ink (also called nut ink or oak gall ink) is commonly found in manuscripts from the Middle Ages. It's traditionally made from gall nuts, the bobbly growths found on oak trees. The ink is naturally acidic and dries slightly translucent.

If you have inks at home that haven't seen the light of day since art school, why not get them out and try them? They may need reviving, or adjusting to the right consistency, with a drop or so of water but it's well worth a try before you go out and spend money.

PAPER

Once you've enjoyed filling the practice sheets in this book, paper pads from a brand called Rhodia are excellent; they do not bleed easily and are gorgeously smooth to write on. The paper is also just about thin enough that you can put guides underneath it when practicing. I particularly love Rhodia's dotPads, which have a faint grid of dots on each page to help you stay on a straight line but without being too prescriptive.

In general you want to choose paper that is smooth but not shiny. Coated, shiny papers are less likely to hold the ink—it will form puddles and won't be absorbed.

TIP // Paper quality can usually be determined by weight, which is measured in grams per square metre in the UK and in pounds in the USA. In general terms, a "good-quality" paper in the UK would weigh at least 120g/m² (or upwards of 30lb).

TIP // Note that different papers prefer different ink viscosities, so don't discard an ink because it has bled; it might work perfectly on an alternative paper. It can be a complex alchemy.

Recommending standard printer paper can be challenging as there are so many different ones out there. I'd forgo cheap inkjet printer paper as it will almost certainly give you trouble. Most inks will "bleed" on lower-quality paper (this is the furry effect that appears around the edges of your calligraphy.) But you could also try good-quality laser printer paper. Be sure to test it before stocking up.

Bristol board is a smooth white card that's great for calligraphy—but it's not cheap so keep it for your final pieces rather than for everyday practice.

Watercolor paper is by nature not very absorbent, so thinner inks shouldn't bleed. But it is fibrous so you'll need to be careful of your nib catching as you write. Avoid using very sharp nibs.

Layout paper is a kind of tracing paper that's not essential when you're starting out but handy to have as you start to create artwork.

CARING FOR YOUR TOOLS

Keep your nibs clean and dry. Once you've cleaned off that oily layer on your new nib, it is susceptible to rust. Even the moisture in the air could rust your nibs over time, so store them in an airtight container if possible and try not to leave them in water for any length of time.

Have a pot of water and a lint-free cloth (paper cocktail napkins also work well as they're not too fibrous) on hand to remove dried-on ink or the paper fibers that sometimes become caught in the nib. A good-quality soft pencil like the Blackwing pencil and a dust-free eraser will also be handy to have in your toolkit.

2

Getting Started

PUTTING YOUR PEN TOGETHER

Once your new nib is prepared, the body of the nib slots into the penholder. If you're using a Speedball straight penholder, it will slot in anywhere around the ring-shaped opening at the top. If you are using a penholder with a metal claw inside one end, then your nib will need to sit between the rim and the claw (not within the grip of the claw itself). Push in the nib until it feels snug. Roughly ¾ in. of nib should poke out.

To assemble the Speedball oblique penholder, the nib slots into the ring at the end of the flange, so that it leans to the right.

HOW TO HOLD THE PEN

In order for your nib to operate efficiently and avoid any scratchiness, you'll need to make sure you're holding the pen in a certain way:

- Hold the pen in a firm but relaxed grip between your thumb, index and third fingers, with your wrist and forearm resting gently on the table. Your thumb shouldn't tuck over your fingers. Your fingers should be relaxed and neither tightly curled up, nor completely straight.
- When using a straight penholder, the nib should always point straight up to the top of the page, with the length of the pen in line with your arm, i.e. perpendicular to your line of writing. Feel free to position your practice paper at an angle that's comfortable for you. As a right-hander, I tilt my paper a little to the left.

TIP // It's hard to change habits of a lifetime but the correct position for calligraphy is probably very different from how you hold a biro or fountain pen. Stop and check your grip often, as you will revert to your natural handwriting position without realizing it.

When you move to an oblique penholder, the long part of the pen should remain in a similar position to your straight holder, but allow the angle of the flange to help you achieve your desired slant. When in this position, the angle of your downstroke should be in line with your nib. It can take a little while to get used to, but persevere and you'll soon get the hang of it.

- Apply pressure into the center of the nib, rather than pushing the tip down into the paper.
- Avoid writing on one side of the nib – don't roll it inward or outward. Apply equal pressure to both sides of the nib.
- The pen should be at a 45-degree angle to the page. Positioned too upright and the nib will scratch and catch on the paper. Too low and you will find it hard to achieve ultra-fine lines.
- Relax! Your neck, shoulders, arm, wrist and fingers shouldn't hold any tension. If you grip too hard or tense your neck and shoulders, you won't be able to achieve fluid strokes and it will start to hurt very quickly!

HOW THE NIB WORKS

Gently touch the tip of the nib with your finger and you'll feel instantly that it comes to a sharp point. Take your pen in your writing hand and press down on any flat surface in front of you. Observe the tip of the nib and you'll see that the tines split apart under pressure. This is exactly how "pointed pen" calligraphy works: the more pressure you apply to the nib, the wider those tines will split. The width of that split will determine the width of the line you'll make. So, by pressing on the nib you'll see a thick line on the page, and—by hardly applying any pressure at all, you'll make

a fine, "hairline" stroke using the closed tines. It's this contrast between heavy and light lines that you're striving for, and which will create the lovely ribbon-effect you want to see in your writing.

TIP // The way you apply pressure to pointed nibs to create different line widths is vastly different from the way you use broad-edged nibs, so always be sure to buy pointed nibs if you want to pursue modern calligraphy.

LOADING YOUR NIB WITH INK

In the center of the nib you'll see there is a hole, called the "vent hole," or "breather hole." You'll need to submerge this in the ink. When you approach the page, the hole should be full of ink. Release any excess ink by dabbing the nib on the rim of the jar. Avoid shaking off the ink as you'll risk flicking it everywhere!

YOUR GUIDELINES

The sketch below shows you how to position your letters on the guidelines in this book.

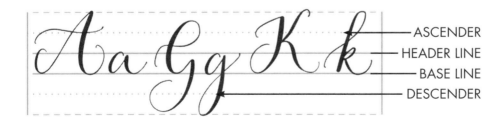

—— ASCENDER
—— HEADER LINE
—— BASE LINE
—— DESCENDER

HOW TO SIT

Sit at a desk-height table so that your paper is flat and close to you, and your wrist and arms are supported, rather than reaching forward over a coffee table or working on your knees. Try to sit up, ideally in a chair with some back support. Keep your shoulders and neck relaxed. I often catch myself hunched over my writing and have to keep reminding myself to sit up straight!

NOTES FOR LEFTIES

As a left-hander, there is no reason that you should be at any disadvantage. You will hold the straight pen in exactly the same position. There are left-handed oblique holders but I know some lefties who also prefer using a right-handed oblique holder. Essentially, you'll have to discover what's most comfortable for you. The Speedball oblique holder is dual-handed so this will be an inexpensive way to find out which you prefer. In fact, when you want to write at more of a slant, lefties shouldn't necessarily need an oblique holder as your hand naturally falls toward the right.

TIP // When using loose sheets of practice paper, cushion your writing page against the hard surface of a table with a few sheets of paper underneath.

3

Exercises

UPS & DOWNS

Now you're ready to start making some marks on the page. The movement should come from your wrist and elbow. Your fingers will move a little but largely should remain still, allowing your wrist and elbow to do the work. Practice this movement with a dry nib on the paper's surface until you get the hang of it.

There is one rule you need to observe: apply pressure to the nib only when you're pulling downward on the page. The nib does not like being pushed upward, which means your up lines must be very light.

DOWNSTROKES = HEAVY
UPSTROKES = FINE

Wherever you see a thick line in the exercises below, the examples in the rest of the book or in any other calligraphy examples you look at, it will always be made in a downward direction.

You should see a clear distinction between your downstrokes and upstrokes. The Nikko G nib is sturdy, so you can apply a good amount of pressure without fear of snapping it. However, you'll find that if your upstrokes are as fine as they can be, you don't actually need to work very hard on your downstrokes to create a good contrast between the two. So find your own comfortable level of pressure, and remember to be as light as possible with your hand.

TIP // Think about the pressure to your down strokes as "pulling" down on the page, rather than "pressing" down on the page. This will help you maintain a light grip.

PERFECT LINES

Don't worry too much if your upstrokes are wobbly at first: this is normal! Those wobbles will quickly iron out with time and practice. It's better to aim for a fine, albeit shaky, line rather than try to steady it by pressing harder.

Avoid any V-shaped "tails" that sometimes appear at the ends of your lines, most often at the bottom edge of your downstrokes. Achieving a clean finish adds a finesse to your work that's worth perfecting from the start. Lift your nib cleanly off the page when you finish the line, rather than allowing the tines to close together again as you finish, thereby creating those triangular tails.

Aim for a consistent line weight from start to finish, too.

GOOD & BAD LINES

TIP // Remember, keep checking: Is your pen straight? Is it at roughly 45 degrees to the page? Are you applying pressure into the center of the nib? Are your hand and shoulders relaxed?

TIP // You'll need to go much slower than you're used to in your handwriting. Your lines or shapes should be slow and controlled from start to finish.

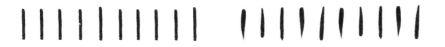

GOOD LINES BAD LINES

BASIC EXERCISES

Try these exercises to practice achieving a contrast in line weight
for your up- and downstrokes:

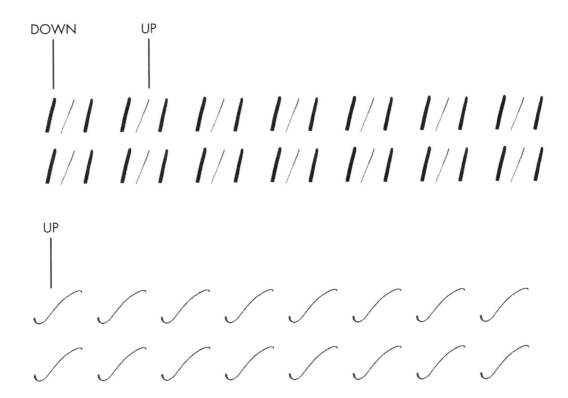

MORE EXERCISES

When you're happy with your line weights, try these exercises.
Here, the aim is to practice smoothly changing from an upstroke to a
downstroke, or vice versa.

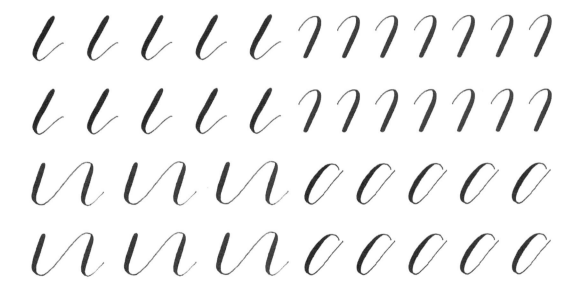

FLOURISHED EXERCISES

This final set of exercises are larger, looser and more open in shape. Now, you'll need to move from your shoulder, keeping your fingers and wrist static, to achieve a wider scope of movement. Keep these shapes light, move much quicker and with a bit of confidence. Go for it!

You're probably itching to start writing pretty letters now but the more time you spend practicing these exercises, the better your letterforms will be. So when you do move on to the next chapter, don't forget about these. Use them as warm-up exercises whenever you sit down to practice.

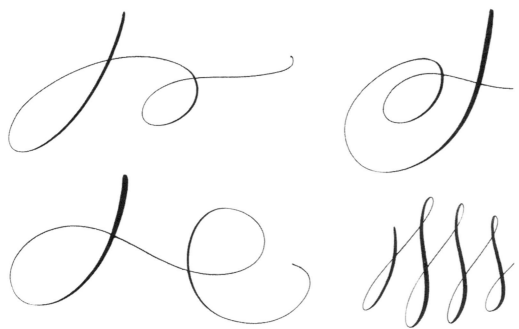

4

The
Letterforms

INTRODUCING THE LETTERFORMS

Approach your letterforms in exactly the same way as the exercises you've just been practicing, applying pressure on the downstrokes and relieving the pressure on the upstrokes.

I want to emphasize again how important it is to think of calligraphy as separate and different from handwriting. Instead of "writing" letters and words as you do when handwriting, you will be "drawing" them instead.

Three pointers on forming your letters:
· Draw them from left to right.
· Aim to be slanted a little to the right rather than vertical.
· Keep them on the slim side, rather than solid and rounded like handwritten letters can be. This will lend an elegance to your letters.

Now it's your turn. Remember, practice makes perfect, so feel free to run on to sheets of plain paper or a Rhodia dotPad once these pages are filled.

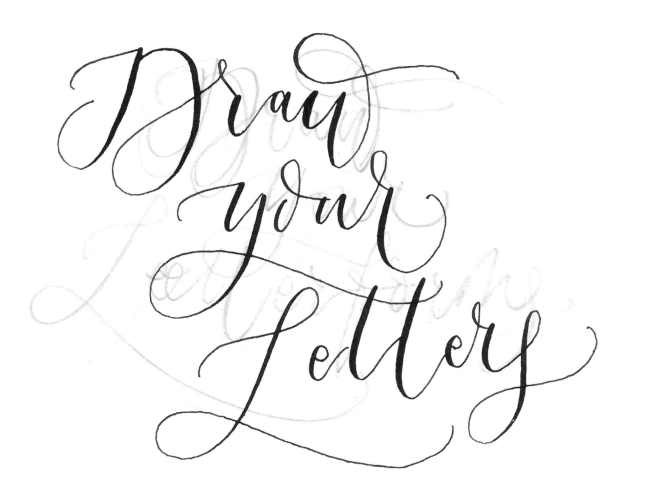

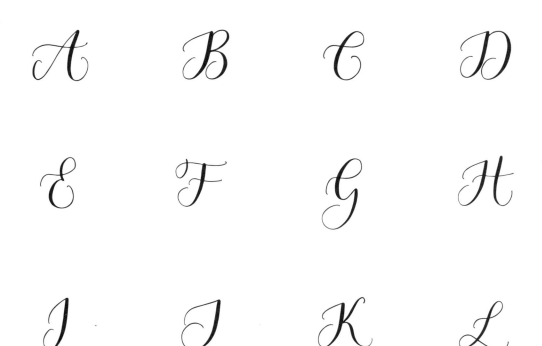

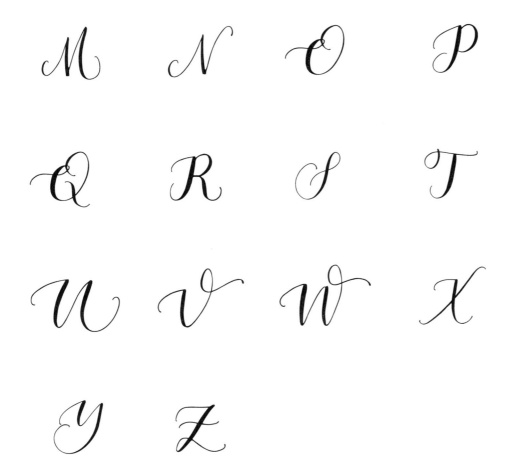

a b c d e f g

h i j k l m n

o p q r s t u

v w x y z

1 2 3 4 5

6 7 8 9 0

& ! ?

A CLOSER LOOK

KEEP IT LOOSE

Looking at these lowercase letters below, note that they have a sense of looseness to them:

HANDWRITTEN · CALLIGRAPHY

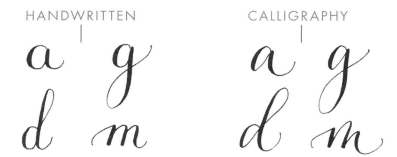

THE CURSIVE "R"

If you're not familiar with the cursive "r," especially if you didn't learn cursive (joined-up) handwriting at school, you may have looked at the lowercase "r" and thought to yourself, "That's not an 'r'!" Do persevere though, as it looks beautiful in calligraphy. I promise you'll grow to love it! Note that the top part of the "r" sits higher than the header line.

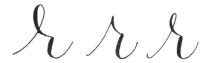

ENTRY & EXIT STROKES

Notice the little lines that sweep in and out of some of the lowercase letters on page 52. These are called entry and exit strokes. The entry strokes act as a decorative flourish when the letter is positioned at the start of a word. The exit strokes are particularly important as they act as connectors to link one letter to the next to make words.

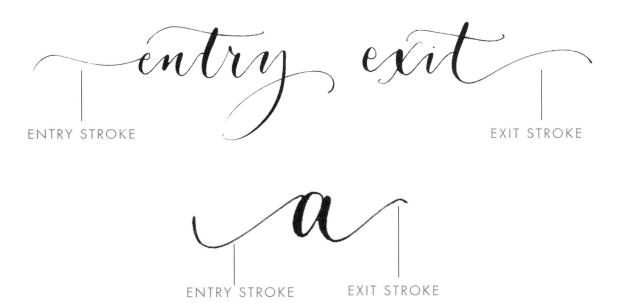

ENTRY STROKE EXIT STROKE

ENTRY STROKE EXIT STROKE

5

BREAKING THE RULES
THE ILLUSION OF JOINING

Joining it all together

BREAKING THE RULES

As you start putting everything together and creating words, consider how you can challenge the unspoken "rules" of handwriting. In modern calligraphy we have an opportunity to add expression, excitement and personality to our letters and words, veering away from the uniformity and orderly structure of traditional script, and indeed handwriting. Think creatively—for example, not all the letters have to sit on one line, nor do they have to be exactly the same size or height. Approaching words in modern calligraphy requires a very different way of thinking than handwriting words. You are building up a composition of shapes one by one to create a beautiful and balanced piece of lettering:

I must have flowers always and always

— CLAUDE MONET

THE ILLUSION OF JOINING

To make words, you must create the illusion of joining, but in reality you're going to be writing just one or a few letters at a time. The key to this is in those exit strokes, which should end exactly where you want your next letter to start. This creates a seamless connection from one letter to the next.

At first, you'll need to retrain your brain to stop writing words without taking your pen off the page, which is really hard when you've been writing in a certain way for years! But it's so important: slowing down and writing just one or a few letters at a time allows you to move your hand along, keeping your pen in the correct position directly underneath your writing; it means you have good stopping points to refuel your nib when writing longer words; and it allows you to focus on creating each individual letter beautifully.

With experience, and as you start to develop your style and experiment, you may feel that a wilder and more organic lettering style requires you to speed up and join more of your letters together.

Let's start with some small words.

First, break down the word into parts so you can see how they will join together:

moon sun

rain

wind star

Now put those letters together to make words, remembering to write one letter at a time, but creating the illusion that the word was written joined up:

moon

sun

rain

wind

star

Now try making longer words by extending the words you've just practiced:

moonlight *sunshine*

rainbow

windmill *starry*

Now try your own words in the same way:

6

Getting Creative with Words

Now let's look at other ways we can put the "modern" in modern calligraphy. It's time for you to get creative! Every modern calligrapher has their own style and now that you're one too, you are very much encouraged to develop your own take on this beautiful art form. Of course, there are a few rules to stick to, such as retaining the modern calligraphy letterforms—slanted ovals, looseness of your letters and so on. But it's up to you to "design" your words and texts, developing a consistent set of "guidelines" as to how your letters are formed, joined, slanted and presented on the page. The key is in creating a sense of balance. It's all trial and error, and you can decide what you like and what you don't. Your own style will develop simply from playing around and trying different things. Over time your modern calligraphy style will come together.

SCALE & POSITION

Consider the scale and position of your letters. Your letters don't need to be all the same size, or sitting on one line. It's all about balance. Introduce a "bounce" to your baseline by dropping some exit strokes below the baseline. They should start to develop a rhythm. It takes a conscious effort initially but it helps contribute a contemporary look to your calligraphy style.

TIP // Don't get hung up on making the capital letter extra fancy, ignoring the rest of the word. Every letter has its part to play.

Chocolate Chocolate

JOINING CAPITALS . . . OR NOT

There's no rule that says you shouldn't join your capital letter to your second letter. It all depends on how you choose to design the word. Some capitals like "I" don't join quite as stylishly as others, so I'd recommend keeping them separate. Here are some examples:

Paris *Paris*

Milan *Milan*

Tokyo *Tokyo*

DOUBLE LETTERS

When you have a double letter, think about how you can present one of

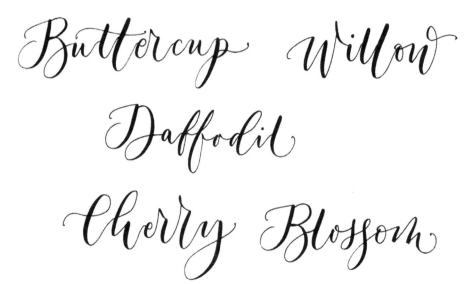

them slightly differently from the other to add interest.

SPACING

The exit strokes determine the spacing between each letter. Without noticing, you'll revert to handwriting-influenced spacing, but when you break free of this mold, you can get interesting results! The key is to keep

lovely

lovely

lovely

the spacing regular, regardless of how wide or narrow you go.

<u>BEGINNINGS & ENDINGS</u>

Again, experiment using the entry and exit strokes to begin and end your word in a more expressive way.

Apricot

Apricot

fig

fig

Walnut

Walnut

FILLING SPACE

Think about the spaces between your ascenders and descenders (known as "negative space") and how you can use the letters to fill those spaces in more creative ways. It could be as simple as elongating the crossbar of a "t" to fill out the space, or a cleverly joined set of letters, or exploiting the loops of a "y."

Sophia

Andrew

Victoria

Emily

DEVELOPING YOUR OWN ALPHABET

Just as there's no single way of writing a word in modern calligraphy, there are also many, many ways you can present each capital letter. Here are some examples; see if you can design your own!

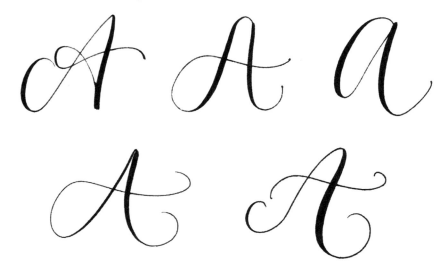

Now it's your turn. Try out the above, use all the techniques and see if you can put the "modern" into your modern calligraphy . . .

Challenge: How many different ways can you present your own name?

NOTES ABOUT PRACTICING

Practicing can have a meditative effect and you'll find you lose many hours absorbed in your work. But practice is an art in itself. It's tempting to sit down and write every word you can think of, but it's easy for your handwriting brain to take over this way. Tackle one word one step at a time. Break it down: letters, then small groups of letters, then build it up until you have perfected and developed each word. Here are my top tips for practicing:

- Write nonsense! Try writing letter combinations that are unfamiliar to help you focus on one letter at a time.
- Practice little and often, perhaps thirty minutes two or three times a week if you can. Your materials shouldn't take up much room, so create a dedicated area at home where you can set up your pen and paper so that whenever you have a quiet few minutes you can get some practice in.
- Give yourself a clear goal for each session. This could be perfecting a certain letter, getting comfortable with those joins, just practicing flourishing, or working on the composition of a specific word. You'll see much quicker results with focused practice.
- Learn to critique your own work. Take a step back and look at it. How could you improve it? How could it be more balanced? How could you improve consistency? How could you make it more interesting?
- Practicing calligraphy should be fun, so create an environment that makes you comfortable and happy. Put music on and have a cup of tea at hand (but keep it on the opposite side of your writing hand, otherwise you might dip your pen into it by mistake!).

Practice

Makes

Perfect

7

Exploring Color

Now that you're becoming confident with your lettering, it's time to branch out, try something new and introduce color into your calligraphy.

GET CREATIVE WITH COLOR

Experimenting with color is where modern calligraphy gets really fun. There are so many exciting mediums you can experiment with. Basically anything that is in liquid form and leaves a mark on your paper can be used for calligraphy, so get creative . . . you could even try using strong coffee on tea-stained paper for an old-world parchment effect.

METALLIC INKS

There are several ready-to-go liquid metallic inks, some of which are better than others. The downside to liquid metallic inks is that you have to keep shaking the bottle or mixing during use, as the heavy metallic pigment settles quickly, and they are not always quite as shimmery when they dry. My all time favorite metallic inks are the palettes from Finetec. They come as a solid disc of pigment made from mica, a type of naturally forming mineral, so they need a little effort from you to make them into the liquid ink that you need, but once you try them you won't look back!

Add a few drops of water onto the disc and wait a minute or so for it to soften. With a small paintbrush, work more water into the pigment until you have created a liquid ink the consistency of milk. Load your brush with the wet ink and brush it onto the underside of the nib. Be careful not to overload the nib—you want to avoid a large blob of ink falling off the nib onto the page.

WATERCOLORS

Using watercolor paint for calligraphy lends a lovely wishy-washy effect. As with the Finetic inks, work water onto the solid watercolor disc with a paintbrush to generate the liquid paint, and then brush it onto the nib.

Kind words cost nothing

MAKE YOUR OWN COLORED INKS

Mixing your own colored inks is easy! You'll need gouache paint, which you can find in little tubes in any art shop, distilled water (or bottled water if you're stuck), and liquid gum arabic. Stock up on gouache paints in primary red, primary yellow, primary blue, black and white. With these you can create any color under the sun.

Red + yellow = orange
Yellow + blue = green
Blue + red = purple

Squeeze a little paint into a small jar and mix to your perfect hue, making sure all the pigment is thoroughly blended together. Add distilled water a drop at a time, using a pipette if you have one, until it's as runny as light cream. Keep testing it on paper as you go, making sure to rinse and dry your nib each time. If you add too much water, leave the ink open for a couple of hours to allow some of the water to evaporate. Once you have your perfect ink, add a drop of gum arabic to help the pigment to bind together. Pop the lid on the jar between uses to stop it from drying out.

The advantage of mixing your own inks is that you can make them the perfect consistency for your "hand." For example, if you write quite slowly you'll want an ink that's a little thicker, while speedier modern calligraphers or those who have a wilder lettering style will find that a runnier ink is preferable.

TIP // Gum arabic is a natural (and edible!) substance formed from the sap of an acacia tree. It's a handy addition to your calligraphy toolbox—you can buy the hardened crystals but it's much easier to buy it already in liquid form—and is an essential ingredient in making your own inks from gouache. If you don't use it, just be aware the dried gouache-based inks may crack and flake off the page.

TIP // Gouache rarely bleeds as it's so viscous. You could even make your own black ink with black gouache, so if in trouble use gouache!

WHITE INKS

White calligraphy on black paper is a classic combination that never fails to please. I use white ink a lot for event projects, contrasting it against midnight blue or rich gray envelopes for formal occasions. White ink also looks effective on kraft brown paper for a vintage-inspired look. And of course white ink on red cards and envelopes is always a winner at Christmas time.

One of my favorite and most used white inks is Dr Ph Martin's Bleedproof White. It dries to a chalky matte finish and is opaque on black or dark colored paper. It needs diluting, so scoop a little out into a clean lidded jar and add a drop of water at a time until you have a consistency like light cream. Always test that you're happy with the consistency, adding a drop more water if needed. You may want to keep a separate nib for white work, as any black ink residue on your nib will dirty the white ink and might turn it gray.

With freedom,
and the
could not

books, flowers, moon, who be happy

— OSCAR WILDE

8

Brush
Calligraphy

Brush calligraphy has gained in popularity in the last few years as modern calligraphers push boundaries with materials and tools. But actually it's an easy in-road for beginners to try calligraphy and hand-lettering. The effect of brush calligraphy tends to be heavier and less delicate than nib work, which means it can look fantastic laid over digital photos, in logos or for signage.

The principles of brush calligraphy remain the same as dip pen—thin upstrokes, heavy downstrokes—but you'll utilize different parts of the brush tip to create those different line widths.

You can use either a brush dipped into ink, or a brush pen. Tombow's Fudenosuke or Dual Brush pens are fantastic. I'm addicted to them, and they are great for beginners. The Dual Brush pen's tip is much fatter so it can create chunky lettering. The Fudenosuke pen is better for smaller writing, and comes with either a soft tip or a hard tip. Both are great for brush calligraphy.

There are advantages to both methods:

BRUSH PEN

- Mess-free
- Quicker to use (no dipping!)
- Creates lines that are more uniform
- More portable
- The Dual Brush pen comes in a wide range of fun colors, and you can chop and change between different pens and colors easily within one piece of work
- Easier to correct mistakes!

- Organic-looking with texture and character
- Can be used with inks, watercolors and acrylic paints, so you can create a diverse range of effects

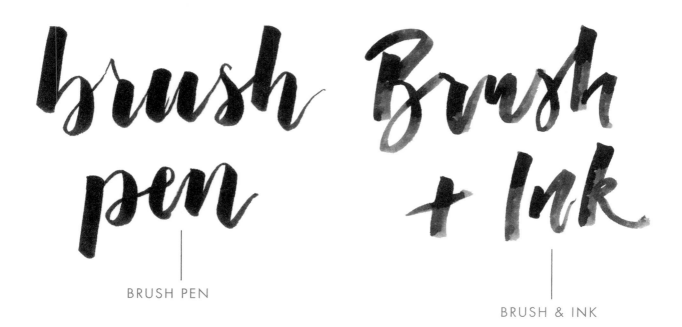

BRUSH PEN

BRUSH & INK

BRUSH CALLIGRAPHY WITH BRUSH & INK

I recommend a size 2 paintbrush, and either india ink or gouache paint in your favorite color for more opaque lettering, or a thinner ink or watercolor for texture.

Grip the brush lightly, near to the tip, and hold it at roughly a 45-degree angle to the page. Take advantage of the bristly coarseness in the lines that appear when you start to run out of ink and incorporate them into the "look"—or, by wetting your newly loaded brush, you can make the ink last longer.

The brush head is likely to splay as you change from an upstroke to a downstroke. You may have to draw circles in two halves, starting at the top and pausing at the base, to reposition your brush ready for the upstroke.

TIP // You can be freer with your lettering with a brush than with a nib. Play with mixing textures and line weights and see what results you can get.

BRUSH CALLIGRAPHY WITH BRUSH PENS

Hold the pen lightly between your thumb and two fingers as you would a pencil. Grip it where the casing meets the tip, and hold it at roughly a 45-degree angle to the page. Unlike with a nib where the pen should remain straight, hold the brush pen slightly out to one side. When you apply pressure to it, the brush tip will bend to one side so that more of it is on the page, and when you pull the brush down, it should make a wide line. Maintain the same angle and position for consistency of line weight.

Thin lines are harder as the brush is so sensitive to pressure. Angle your brush high and very lightly use only the tip of the brush. The closer you hold the pen to the nib, the more control you'll have.

EXERCISES

Practice these exercises slowly with a brush pen first, and then with brush and ink.

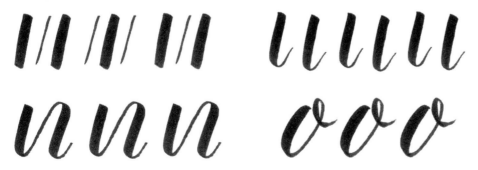

TIP // If the pen is at a more upright angle when you apply pressure to it, it can damage the tip over time, causing it to splay or ruining its sharp point.

TIP // Avoid stopping halfway through a downstroke as it will leave an irreparable join mark.

TIP // You'll need to go slowly to gain the control needed to maintain consistency in your brush letterforms. That said, speeding up will help create a wilder, more freestyle, contemporary look.

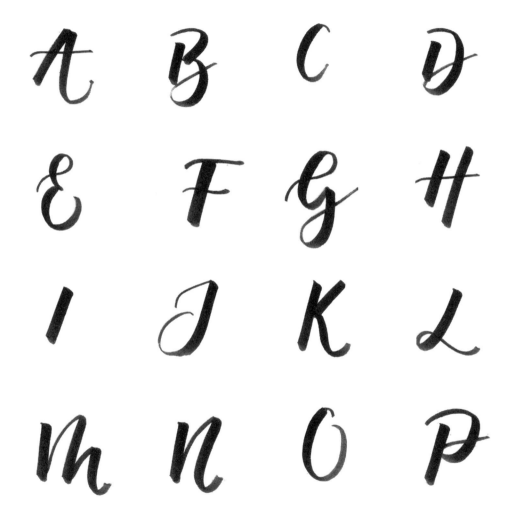

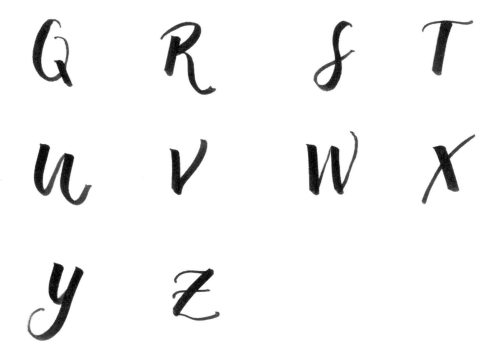

a b c d e f g

h i j k l m n

o p q r s t u

v w x y z

May
your coffee
be strong...

and your
monday
be short...

9

Learning
to
fake it

If you'd like to recreate your calligraphy on a larger scale, or if the surface is too textured or requires a specific type of pen, you won't be able to use a calligraphy nib or brush. So you'll need to learn to "fake it" by creating the same effect with different materials. The important thing is knowing the outlines of your modern calligraphy letterforms, and then it's just a case of filling in your thicker lines where they should be.

Non-porous surfaces such as glass or ceramic may need either a specialist glass or enamel paint, which you would apply with a paintbrush, or a fiber-tipped permanent ink marker. Note that both are solvent-based, which means they won't wash off with water. You'll need to clean your brushes with methylated spirits, and may not be able to tidy up any mistakes easily.

You'll probably need to "fake it" when writing on:
· Chalkboards
· Glass or mirrors
· Timber
· Metal
· Leather

When making your "downstrokes," draw the outer edges first to determine the line weight, then fill in the middle.

On the practice pages that follow, draw your calligraphy letterforms in pencil, or with a fineliner pen that has no flex, and then manually create the downstrokes.

When applying faux downstrokes to words, make sure that the line weights are either consistent, or deliberately inconsistent, for a playful look.

10

Putting it into Practice

TOP TIPS

Whether you're creating your own event stationery, writing menus and name cards for your next dinner party, creating a piece of wall art for your home, or you've been commissioned for your new lettering skills, here are my top tips for putting it into practice. As soon as your friends and family start to see what you can do, you'll be inundated with requests to help with weddings and all sorts of bits and pieces. Before you know it, a new career could be born!

- Always allow a good ten minutes for exercises and alphabet practice so you can warm up. This is especially important if you're working on something you only have one chance to get right. Your muscle memory in your hand needs a chance to get in gear.
- As a calligrapher working on commissions, you won't always have a say in what paper you will be writing on. If you can, test a sample so you can make sure you use an ink that doesn't bleed, that it dries as you'd planned (sometimes thinner inks can lose their opacity on more absorbent papers), and that you are using a nib that doesn't catch on or tear the paper.
- If you need to draw faint pencil lines, check that you can erase them cleanly and without damaging the paper or smearing the ink.

- Mock up your phrase on practice paper first so you can work out your layout, spacing and design.
- Keep your hand and arm relaxed! It's easy to tense up when faced with the blank page of an important piece, but it will be counterproductive. Create a relaxing environment with your favorite music and a cup of tea.
- Keep your hands clean. You will be touching the paper often, and over time the natural oils on your fingers will build up, which could leave grubby marks on your paper. Avoid eating oily snacks or finger food!
- Needless to say, if caffeine or sugar make you shaky, avoid them before a big job!

TIP // Keep your old practice work so you can see your development. Be proud of what you've achieved! You will be your own worst critic and we are always learning— I know I am—but allow yourself to take a step back once in a while and see how far you've come.

PROJECT: THE ART OF THE ENVELOPE

Creating a piece of mail art is a lovely way of sharing your newly acquired skills. Why not make someone's day by sending them some beautifully addressed snail mail?

Your envelopes will look lovelier if they are center-aligned, but it takes time to measure up each line with a rule, and a lot of practice to do it by eye. For a quick job, you may want to consider left-aligning the addresses.

Envelopes always take a lot longer than you think they will, so factor that into your/your client's expectations. The envelopes you do toward the end of the job will be the best as you will be warmed up and in a good rhythm, so leave any VIPs until last. For every 100 envelopes, I always allow for 15–20 spares, in case of spelling mistakes, ink splatters, or I'm just having a bad calligraphy day. Once I was concentrating so hard on the calligraphy that I didn't think to check my pile of blank envelopes was the right way up until I'd written about 20 of them!

If you are going to be writing a wedding's-worth of white or pale envelopes, you can buy a lightbox from art shops to help you. Create a single template to slip inside the envelope, which will be illuminated by the light shining from underneath it, so you no longer need to measure each envelope in pencil.

CREATIVE ENVELOPE IDEAS

At Quill we stock a nifty little tool called "The Lettermate," which really is my friend when it comes to everyday envelope addressing. It's designed especially for this with pre-made slots for each line, as well as handy markings to help center the address. I use these as quick and easy guidelines, which I mark in pencil before writing the envelope in pen and ink.

To add some wow-factor to your envelopes, it's time to get creative again.

- Consider the angle or shape of your baseline—it doesn't have to be straight. How about presenting the address asymmetrically or in undulating waves?
- Can you add interest and surprise by playing with scale and positioning? Perhaps splitting the envelope into columns, or making a feature of the name?
- It can be fun to add a little motif, or glyph into the design. Maybe a leafy wreath, or a floral motif for a garden party invitation?
- If you're short of time, contrasting a cursive style with simple block capitals can still look effective.

TIP // When composing your envelope design, don't forget there needs to be a postage stamp! The last thing you want is to have to place a stamp on top of your beautiful script.

TIP // Be kind to the postman or postwoman. The post office must be able to read the postcode (or zip code) and the house or building name or number to process your mail, so keep these legible. Everything else can be as flourished as you like!

FORMS OF ADDRESS

When it comes to formal event stationery, a playful envelope layout may be unsuitable depending on the tone of the event. Where casual or contemporary event envelopes may be able to get away with first names only, a traditional do may require a formal address:

To a married couple (with the same surname):
Robert and Deborah
Mr. and Mrs. R. Lorimer
Mr. and Mrs. Robert Lorimer
Mr. Robert and Mrs. Deborah Lorimer

To a couple with different surnames:
David and Alexa
Mr. D. Edwards and Miss A. Pearce
Mr. David Edwards and Miss Alexa Pearce

Other common titles:
Dr. Peter and Mrs. Annabel King
Dr. Annabel and Mr. Peter King
Dr. Peter and the Reverend Annabel King
The Rt. Hon. Peter and Annabel King
Mr. Peter and Lady Annabel King

DID YOU KNOW? //
Invitations to private events were traditionally addressed only to the lady of the house, and both names were inscribed inside.

Some notes on addressing envelopes:

- You might choose to substitute the "and" for "&" for a more casual event.
- Particularly for formal weddings, there may be an outer envelope and an inner envelope, in which case the outer envelope should feature the full address, e.g. "Mr. Robert and Mrs. Deborah Lorimer" or "Mr. and Mrs. R. Lorimer" and the inner envelope's address will be shortened to "Mr. and Mrs. Lorimer" or "Robert and Deborah."
- It's customary to address all invitees on the envelope, including young children. Older children no longer living at home should receive their own invitations.
- A note on using Miss, Mrs. and Ms.: Miss for an unmarried woman, Mrs. for a married woman, but defer to Ms. if you're unsure of her marital status. Also safest to use Ms. if she is married but kept her maiden name.

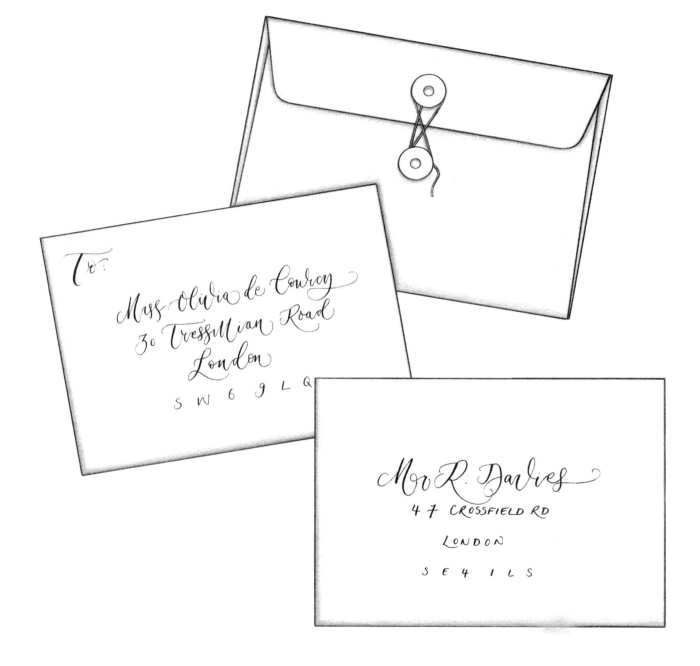

To:

Miss Olivia de Courcy
30 Tressillian Road
London

S W 6 9 L Q

Mr R. Davies

4 7 CROSSFIELD RD

LONDON

S E 4 1 L S

Mr & Mrs T. Wright
140 Clapham Park Road
London
S W 6 1 P G

Mr and Mrs D. Mackenzie
14 Stornaway Drive
Morton, Derbyshire
D E 4 7 R L

Laura
Murphy

40 Brunswick St
Hertford
Herts.
SG4 1LK

Mr and Mrs T. Long,
5 Spring Cottage,
Fairview Lane, Buckland,
Brixham, Devon
EX20 1LD

Lorraine Oswald
16 Cotefield Lane
Woburn Abbey
Bedfordshire
LU9 5KT

Ed and Lucinda
14 Parkhouse Mews
Dartford, Kent
DA1 6 1LP

PROJECT: TABLE STYLING WITH MENUS AND PLACE NAMES

Whether it's for your own dinner party or a client event, styling the dinner table with a little modern calligraphy magic is guaranteed to wow your guests.

I love creating personalized menus, which means you can forgo a separate place card. Depending on the style you want to achieve, you could typeset and then print some elements of your menu, adding in some handwritten touches afterwards. Or handwrite the full menu for a wilder, organic look.

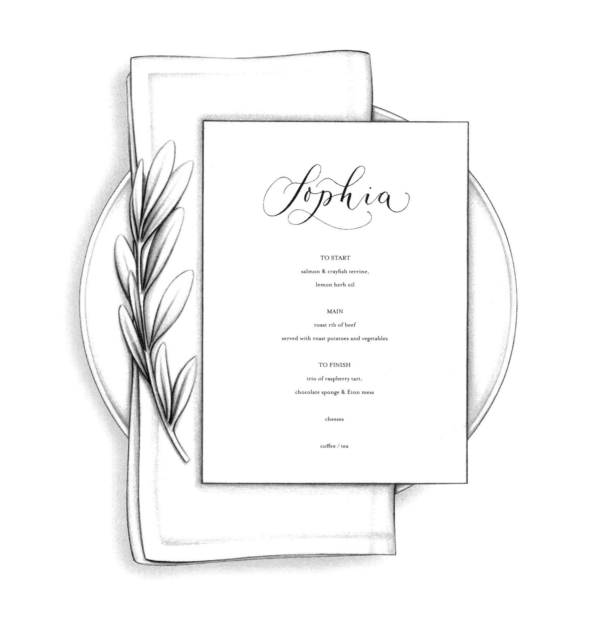

Sophia

TO START

salmon & crayfish terrine,
lemon herb oil

MAIN

roast rib of beef
served with roast potatoes and vegetables

TO FINISH

trio of raspberry tart,
chocolate sponge & Eton mess

cheeses

coffee / tea

There are lots of ways to get creative with your place names too. Why not think beyond paper? With a brush or a marker pen you could inscribe guests' names on leaves, pebbles, driftwood, wine glasses, napkin rings . . .

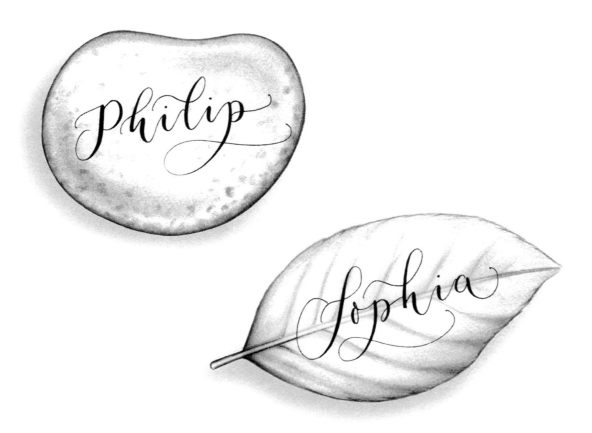

PROJECT: WAX SEALS

I love the charm of wax seals and have an entire Pinterest board dedicated to contemporary stamps and seals. I especially love the idea that you can turn your new calligraphy letterforms into a personalized monogram that you can keep for life. I use Stamptitude.com as their seals are expertly crafted and beautifully packaged too (so important!).

To make the monogram you'll need:
- Pencil and precision eraser
- Rhodia dotPad, or plain practice paper
- Layout paper (optional)
- Fineliner pen
- A good camera or scanner

First, sketch out each calligraphy letterform separately in pencil on paper and keep reworking them until you have two complementary shapes that you like. (Don't worry at this stage about the line weights.) Consider how the shapes could intertwine. Now begin sketching up your monogram. How flourished would you like the letters to be—swirly and curly, or contemporary and minimal? Once you have a design that's "nearly there," you could use layout paper to trace over it, making any tiny adjustments needed to perfect it.

Design completed, you'll need to add some weight to your downstrokes, which you can do just by tracing over your design with a black fineliner and thickening up the relevant lines.

TIP // It will be easier to keep the design on the small side—less than 3" overall.

Use the practice pages that follow to design your own stylish monogram.
For example:

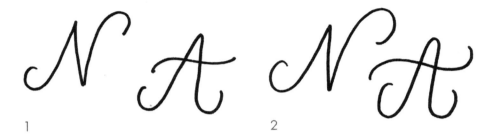

1 2

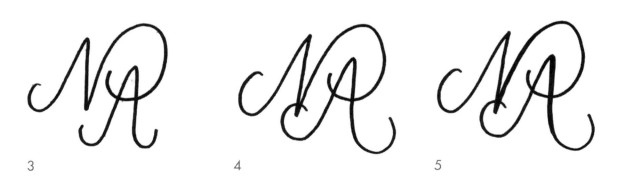

3 4 5

DIGITIZING YOUR MONOGRAM

Now you have a monogram! Scan it in high-resolution format (300dpi+).

If you have access to Adobe Creative Suite, you can use it to turn your monogram into a vector graphic, which is the type of digitized file that printers need to reproduce your work:
- Create a new Illustrator document and import the scanned image using the "Place" command.
- Open the "Image Trace" tab and click on your image.
- Set the mode to Black & White and make sure you have "Preview"' mode selected. You will now see your image become a vector. If this does not work, try rasterizing your image first by going to "Object" and then "Rasterize."
- Change the threshold accordingly to pick up more or less detail. With preview mode on, these will update as you make changes so you can easily make as many or few changes as you need.
- When you're happy with what you see, select "Expand" in the top toolbar.
- Then select "Ungroup" and delete the white background and anything else that isn't part of the design.
- Use the "Smooth Tool" to smooth out and correct any wobbly lines.
- Save as an EPS file.

If you don't have access to Adobe Creative Suite, Stamptitude.com has an online tool where you can upload your scanned image for a small fee, and they will work their magic on it before handcrafting your seal.

Of course, once you have your monogram design, you can use it for all sorts of things—a logo for your event invitations, a header for personalized stationery, etched into a piece of jewelry or your own wax seal . . .

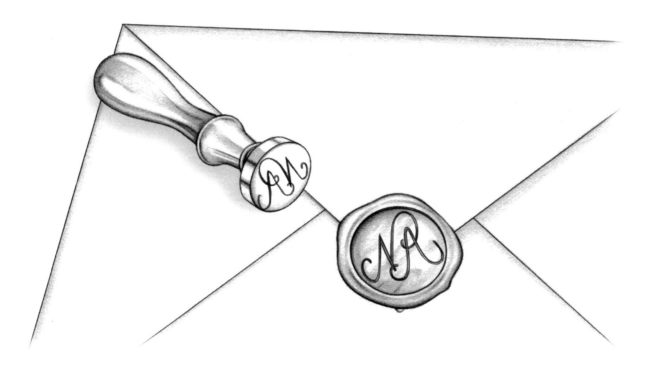

PROJECT: CHALKBOARD SIGNAGE

When you're working on a large-scale piece of work, even on paper, you can't use nib and ink because the contrast between thick and thin lines will be hardly noticeable. Therefore when attempting chalkboard signage, we need to draw the lettering and then add the thickness to the downstrokes afterwards.

You'll need:
· A board painted in chalkboard paint
· Chalk or chalk pen—I use posca pens
· White pencil
· Damp cloth and wet cotton buds
· A4 paper and pencil

You can buy online pre-painted plywood chalkboards any size or paint a wooden board yourself with chalkboard paint (not to be confused with Chalk Paint), which is available at most hardware stores.

You can use good old-fashioned chalk sticks—easy because they are wipe-clean—or chalk pens, which are widely available too, but permanent. You'll need to repaint the board if you make a mistake with these.

TIP // Sharpen your chalk sticks first with a wide make-up pencil sharpener.

TIP // Seal your chalk lettering with spray fixative, which you can find in art shops, or even hairspray! Make sure to spray lightly in fine layers from a distance.

Mock up your design in pencil on paper first—A4 paper is fine; it doesn't need to be the same size as the actual board. Introduce a variety of lettering styles and sizes for the various parts of your content to keep it interesting. Refine your design in pencil before starting on the board!

When you're happy with the mock-up—including the placement of your faux thick lines—sketch the design very lightly onto the chalkboard in white pencil. White pencil is difficult to wash off, so go easy and keep it light. Finally, go over your pencil markings with chalk or chalk pen. If using chalk, you can refine any errant lines with a damp cotton bud.

When adding thickness to the "downstrokes," keep them consistent, whatever thickness you choose (I'd normally go for three times the thickness of the thin "upstrokes"). Mark in the outer edges of your thick line, then fill in the gap.

Prop your board on an easel or chair and wow your guests!

Welcome
to the
Party

FAQs, Resources & Suppliers

FAQS

Is calligraphy messy?
Like any art form it can be, but in day-to-day practice the mess is usually limited to your fingers unless you have a major ink spillage. So be sensible when it comes to the clothes you're wearing when practicing, and make sure to protect your furniture. I'd advise keeping a wet cloth handy and covering any bare, unvarnished wood surfaces. Try to avoid the ink coming into contact with your nails, as the ink might stain your skin for a day or so but takes longer to come off your nails.

Can you get a modern calligraphy pen with ink inside so you don't have to dip?
The only ink pen I have found with a pointed nib suitable for modern calligraphy is Noodler's Creaper Flex fountain pen.

How long do the nibs last?
This depends on so many factors: how much you've used them, how textured the paper you've used is, how acidic your ink is . . . Some telltale signs that you need to toss your nib are when it gets scratchier, or when you can no longer achieve fine hairline strokes. This is usually caused by the tines not springing back together tightly, or the tip becoming blunt with wear.

Why am I getting lines that look like this?

This just means your ink has run out and you need to re-dip. When your nib is brand new it may do this more regularly for the first page or so. But preparing your nib correctly (see chapter 2) will improve ink flow.

Why is my nib not working properly?
Have you prepared it thoroughly? See chapter 2 for full instructions. All new nibs need preparing before using them for the very first time. Also some nibs just take a bit of taming, patience and getting used to. You may need to experiment with your pressure, or see if it works better with a different consistency or a different paper surface, especially when you try a nib type that you haven't used before.

How do I stop a shaky hand?

Shakiness generally has nothing to do with your skill level or experience. We all experience shakiness at some point, although it's more common when you're starting out. Try experimenting with different letter sizes as you'll probably find that writing a little bigger or smaller may help you. Find your sweet spot.

Rather than starting cold on an important piece of calligraphy, make sure you've warmed up your hand with some exercises for 10–15 minutes, as your lines will be much smoother after a bit of practice, no matter how much of a pro you are.

Why is my hand hurting?

You are probably gripping too hard. Remember to relax all your muscles from your neck down to your shoulders. If you are hunched over a computer at work all day you might carry a lot of tension in your neck and back. Or if you know that you grip a normal writing pen hard, be prepared to keep forcing yourself to sit back, stretch out your hand and relax your grip every few minutes until it becomes more natural.

How should I look after my materials?
Please always clean and dry your nibs after every practice session. You can do this with water most of the time but you may have to rely on a specialty pen-cleaning fluid to remove some of the stubborn stains that build up over a long period of time. Drying your nibs after cleaning will stop them from rusting. Store your nibs in a clean, airtight container, and ideally don't leave them inside your penholder after practicing.

Can I use any type of ink/paint?
Any water-based medium should work to a greater or lesser degree. Just make sure it's not oil-based (i.e. solvent-based). Different nibs work better with thicker or thinner inks so if you find it doesn't work with one nib, don't give up just yet—try a different nib type. If you've bought a new ink and found it to be too thick, or mixed your own and discovered it doesn't descend your nib, all is not lost. Just add water! You could also try adding a drop or two of gum arabic, which should help increase its viscosity. And if it's too thin, try leaving it out with the lid off overnight.

Why am I getting bits of paper stuck in my nib?
It might be because you're pressing too hard, or because you're sketching over a wet line, for instance if you're trying to fill in the gap between the lines where you ran out of ink. Always avoid writing over a wet line. Remove any fibers by swilling the nib in water; then open the nib by applying pressure to its tines while removing the fibers with a cloth.

RESOURCES AND SUPPLIERS

At Quill we stock all our favorite and most-used calligraphy supplies, both online at Quilllondon.com—we ship worldwide—and in our Islington store, including most things recommended here in this book (alongside all of our lovely stationery of course!)

37 Amwell Street
London
EC1R 1UR
Quilllondon.com

There are also other fantastic suppliers in London and beyond. Art shops are the best places to find paints and pigments from which to make your own inks and mediums, as well as useful papers such as Bristol board, layout paper and Canford black. Unfortunately, since modern calligraphy is a fairly new phenomenon, most calligraphy "departments" of art shops tend to rely heavily on supplies more suited to traditional calligraphy scripts, such as broad-edged nibs that are useless for us!

Online
Scribblers.co.uk
Blotspens.co.uk
Paperinkarts.com
Johnnealbooks.com
Jetpens.com

Stamptitude
My go-to maker of beautiful wax seals.
Stamptitude.com

With modern calligraphy gaining an ever-increasing following worldwide, it's an exciting time to join this wonderful community of creatives. There are tons of blogs and online forums that can help you.

The Flourish Forum
A phenomenally helpful resource, where you can learn, share experiences and ask questions.
Theflourishforum.com

Modern Calligraphy Summit
Offers a wealth of resources to its online community, and a yearly intensive online course.
Moderncalligraphysummit.com

Besotted Blog
I particularly love the calligrapher interview feature on Tristan and Michelle's blog—it's reassuring and inspiring to read the stories of the great and talented calligraphers

I admire, and be reminded that they started from scratch too.
Besottedblog.com

The Postman's Knock
Lindsey's blog is a hugely helpful resource for anyone starting out or needing a helping hand as they go along. There are tons of videos and clear instructions, and Lindsey also offers inexpensive guide sheets for her own modern calligraphy lettering styles.
Thepostmansknock.com

Calligrafile
Molly Suber Thorpe, author of *Modern Calligraphy*, a book that has helped modern calligraphy reach so many people worldwide, has launched an extensive online resource for letterers. At the time of writing it has only recently gone live, but looks to be an essential bookmark.
Calligrafile.com

Pinterest, Instagram & YouTube
Social media is surely responsible for the spread of modern calligraphy fever! These days you can learn the basics just from Instagram videos. The modern calligraphy community is full of lovely people that are happy to share information and answer questions. Be inspired . . . I love that the beautiful work of my favorite calligraphers around the world pops up on my Instagram feed every day. Find heaps of inspiration at #moderncalligraphy

thank you

To my mum and dad. You taught me the art of practice.

To Alex, for supporting me unfailingly. I am indebted to my sister Jen, and to Alexa and everyone on our team, who work very hard for the success of Quill. You are the glue that holds it all together.

Special thanks to Hannah Hornigold and Lisa Mavian, whose generosity and input has been invaluable.

I am profoundly grateful to my editor Olivia Morris; Loulou Clark, who designed this book; and the wonderful team at Orion who have championed it and made the writing of it such a gratifying challenge. I am bowled over by your support: thank you all.

And finally, to our fantastic community of calligraphy enthusiasts, who inspire me every day with their passion.